Bataille's Dog

(DIS)INTEGRATING WITH BATAILLE & BAUDELAIRE

MAIA NEWLEY

INDEX

PREFACE .. 3

FOREWORD .. 5

BATAILLE'S DOG ARTWORKS 7

PREFACE

About Maia Newley

Maia Newley is an abstract expressionist artist who lives between the USA and the UK. Her work focusses predominantly on colors, textures and emotions and the interplay between all three. Her previous series have included "Dante – Inferno – Hell" and "Faustus – Denouement – The Conclusion" which both explore the relationship between mankind, evil, eternality and man's belief in the supernatural.

She has exhibited in the USA, UK and Europe and is committed to producing 'accessible art' which is shown in appropriately accessible environments. She has regularly shunned opportunities of exhibiting in conventional galleries in favor of open-air, freely-accessible exhibitions and open-space galleries which offer full access to visitors with no entrance fee. She strongly believes that art belongs to everyone and should not be viewed any differently to music (which she also composes) – everyone should have free access to art if they wish to view it. She views her work as coming from an anarchistic start point and, for this reason, she endeavors to ensure her work is available and viewable to anyone who wishes to see it, regardless of income, status or education. As Maia herself says :

"... There are some galleries I have exhibited in in the past, where even I, as the artist, feel uncomfortable going in the door – as though I am entering some hallowed hall where I can only walk in if I am wearing the right outfit and only speak in whispers using words of more than three syllables. Goodness alone knows how the casual passer-by might feel on seeing the work through the window and wishing to pop in to view it in more detail. I do not want my art work displayed in such a place. Life is art and art is life, and therefore is it imperative that we do not separate the two or put one on a pedestal above the other."

Although Maia works predominantly as an expressionist, she also has occasional forays into the areas of symbolism and fauvism. Over the years she has worked with a plethora of different media including sculpture, stone casting, metalwork, pyrography, stained glass window design and more conventional painting. She is also a photographer.

When asked about her work, Maia says :

"I don't have a whole lot to say really as I prefer the art to speak for itself. In my opinion art needs to be accessible to all those who wish to see it. What any given piece means to me is mostly irrelevant as the viewer should decide what it means to THEM. In this way, I hope that each piece can develop its own meaning for each person who views it.

I prefer not to give long explanations with the artwork as, for me, art is about feeling and emotion and not about words.

My main interest is in producing pieces which focus on areas of the world about us which we mostly don't bother to look at! Individual rain drops, small parts of brickwork, clumps of earth – in other words, I focus on the minute details which do not generally draw our attention when we look at the overall subject matter.

My work is mostly abstract expressionist in nature, but I seem to have a natural affinity with symbolism which is hard to shake-off and so much of my work is underpinned with a symbolistic conception which then mutates and grows into its expressionistic form. I find the fusion of the two styles is probably the best way of understanding who I am as a person – that paradox, between the more stylized and regulated symbolism and the randomness of the expressionistic conclusion accurately reflects the seemingly interminable conflict which exists within my mind between order and chaos. After years of trying to resolve the conflict, I have now finally concluded that I am who I am BECAUSE of that conflict and not in spite of it!

If you're looking for representational art, you won't find it here! For me, if you want to look at fine art paintings of landscapes, buy a camera and take photos! If you want to look at how a landscape makes someone FEEL, look at art".

"An artist is a kaleidoscope endowed with consciousness"*
(Baudelaire, Charles : Quote)

FOREWORD
BATAILLE'S DOG

*"Always be a poet, even in prose."**

The Bataille's Dog series of artworks are inspired by the works of Georges Bataille and Charles Baudelaire. The name of the Series is taken from the book "Rousseau's Dog" which outlines the lifelong rivalry which existed between the philosopher and social commentator Jean-Jacques Rousseau and the philosopher David Hume.

A Brief Word about Bataille and Baudelaire

Georges Bataille is almost impossible to define - he was a writer, a thinker, a philosopher, an archivist and an artist. He despised labels and, indeed, his final book was simply a series of images as he had by that point, given up on verbal/textual communication finding it mostly paradoxical and pointless. Bataille's most famous works were a novel entitled "The Story of the Eye" and a series of more philosophical writings such as "Visions of Excess" and "Literature and Evil". He also wrote poetry and much of the prose he wrote was very lyrical and rhythmic (Tears of Eros for example). Bataille also ventured into the arena of economics, writing The Accursed Share, in which he presents his new 'economic theory'. In The Tears of Eros (which one might call the culmination of many of his other philosophical works) Bataille looks at the connection and relationship between violence and the sacred. Much of Bataille's work carries this as a central theme and he spends a great deal of time inquiring into the very complex relationship between violence, power, love and eroticism.

Charles Baudelaire is more accessible but no less fascinating for that. He was, essentially, a poet and his most famous work is The Flowers of Evil which contains a variety of themed poems including possibly his most famous works, Spleen and Ideal. He also wrote "The Painter of Modern Life" (which contains other essays) in which he muses on politics, war, modernity, art and lifestyles. He has a similar 'take' on life to Bataille but writes with purposefully more finesse and less crudity (hard to be as crude as Bataille though, to be honest!) Baudelaire is also known as being one of the first (if not the first) translators of Edgar Allan Poe into a language other than English (French in Baudelaire's case). Baudelaire was also an essayist and an art critic and, later in his life, he translated the absolutely wonderful book by Thomas de Quincey, "Confessions of an English Opium-Eater" into French.

About the Bataille's Dog Series

Georges Batailles was one of the most important thinkers of the 19th Century and yet nowadays his work often seems destined to lounge in the dump bins of academic research, rarely poking its head above the metaphorical parapet. As a writer, Bataille is a paradox, regularly making sweeping statements at the beginning of a chapter only to utterly renounce the same statements at the end. Sometimes it doesn't even take a chapter! And yet, this very paradox is central to his thought process and to understanding the work he produced. He notices the interminable paradox that we

all live in, he realizes that art and life are both mutually exclusive and completely inseparable at exactly the same time and tries to articulate the chasm which this knowledge so often leaves at the bottom of the abyss. He was fascinated by Hegel, obsessed with the Marquis de Sade and generally very impatient with the artists and poets of the day as evidenced by his extraordinary friendship and hatred of Eugene Delacroix whom he at one point near-worshipped, and at another despised.

Charles Baudelaire, coming slightly later than Bataille, seems to have made a concerted effort to make himself more palatable to a general audience. Where Bataille speaks the language of Sade, Baudelaire speaks the language of Poe – he is equally dark and at times despairing, but his linguistic style is more accessible and less overtly threatening than that of Bataille. Where Bataille almost shouts obscenities at his readers, Baudelaire requires us to unpick the sinister undertones and implications of his words for ourselves. Flowers of Evil is arguably one of the greatest poetry anthologies ever written and yet, despite his accessibility, he remains best known for being the first French translator of Poe rather than for the extraordinary poetry and prose of his own.

I wanted to find a way of bringing both writers to a new audience who might otherwise miss them and to try to articulate their works and thoughts in a purely visual form with the vague idea that the artworks might complement and help to 'translate' or 'interpret' the sometimes impenetrable texts. That was what I had *hoped* to do!

The end result, however, is very far from that! Instead of interpreting or translating their words, I found myself somehow willingly sucked into the abyss alongside them as if by some form of osmosis, it became an organic fusion of concepts and ideas which took on a life of their own and left me with the gradual creeping realization that; whether in textual form or artistic visual form, these concepts have to rely on semiotic sign-posting to a series of base emotions and primal behaviors which the readers or viewers must interpret for themselves.

These emotions and behaviors stand on their own as indicators, and sometimes as answers, to the questions "why are we here?" and "why do we DO the things we do?" and, of course, to the question which humans being have asked since time immemorial "why do we insist on constantly destroying that which exists around us?"

The Series of artworks which fall under the "Bataille's Dog" title are a series of sometimes connected, other time unconnected, works which use a plethora of different mediums. All focussing on human existence, suffering, violence, love, core values and power and the inter-relationship of all of these. In a sense, they are anarchistic artworks and, in another sense, they are more conventional, if non-representational, works - in this way, I aim to reflect the paradoxical center which underpins both Bataille's and Baudelaire's work.

The Bataille's Dog series of artworks focusses on the emotions themselves and hopes only to raise the questions. It does not pretend to provide any answers. The viewer, however, is invited to create their own answers in response to the posed questions.

- Baudelaire, Charles – Quote

BATAILLE'S DOG SERIES

"I believe that truth has only one face: that of a violent contradiction."
(Georges Bataille)

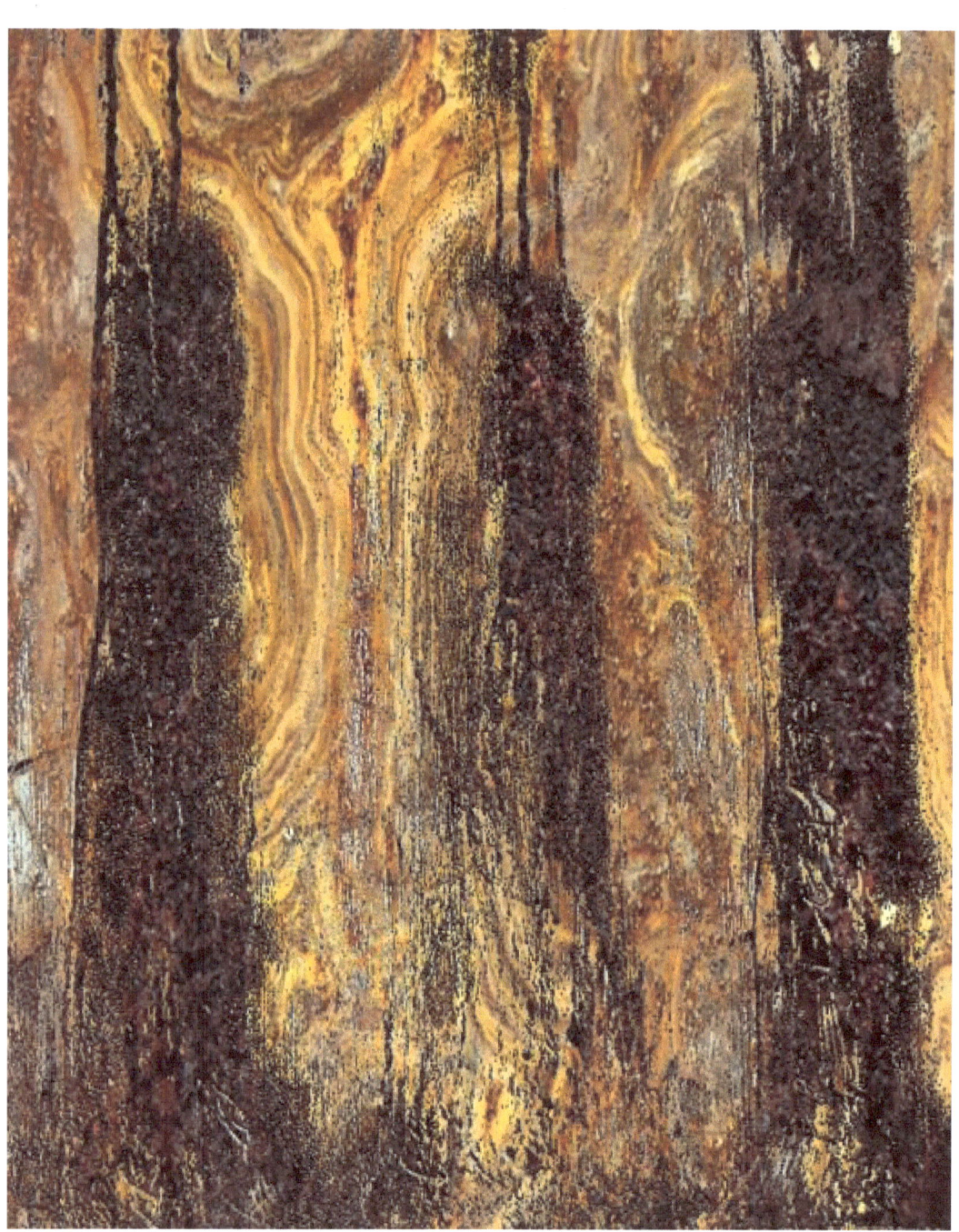

The Repetitive Chaos

*"The world is purely parodic, in other words, each thing seen is the parody of another, or is the same thing in a deceptive form"**

Blow Torch on Gnarled Pine Board

*Bataille, Georges – The Solar Anus

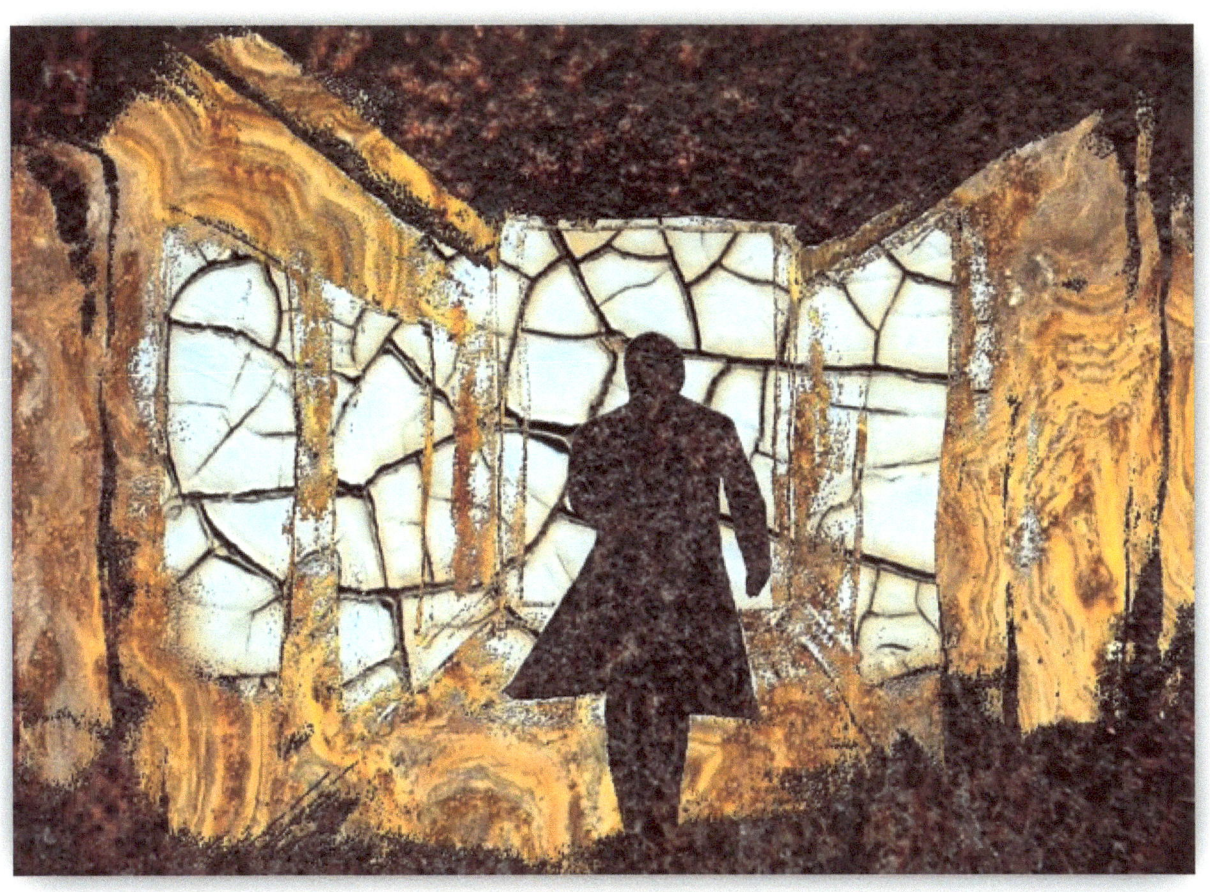

The Forward Step

*"What is the meaning of art, music, painting or poetry if not anticipation of a suspended, wonder-struck moment, a miraculous moment"**

Blowtorch on reclaimed pine wood

* Bataille, Georges – The Accursed Share

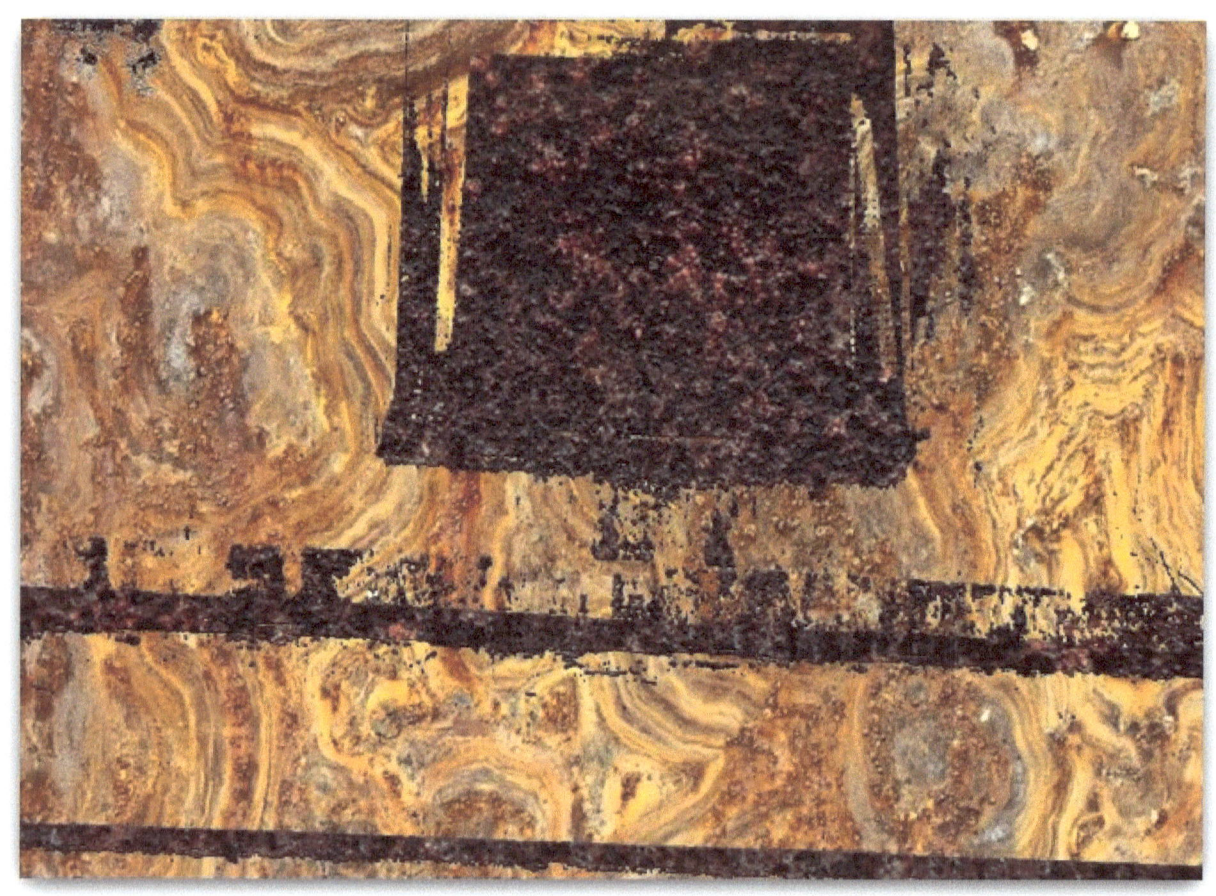

The Escape

*"How little remains of the man I once was, save the memory of him!
But remembering is only a new form of suffering."**

Blowtorch on reclaimed pine board

*Baudelaire, Charles – La Fanfarlo (1847), trans. 1986

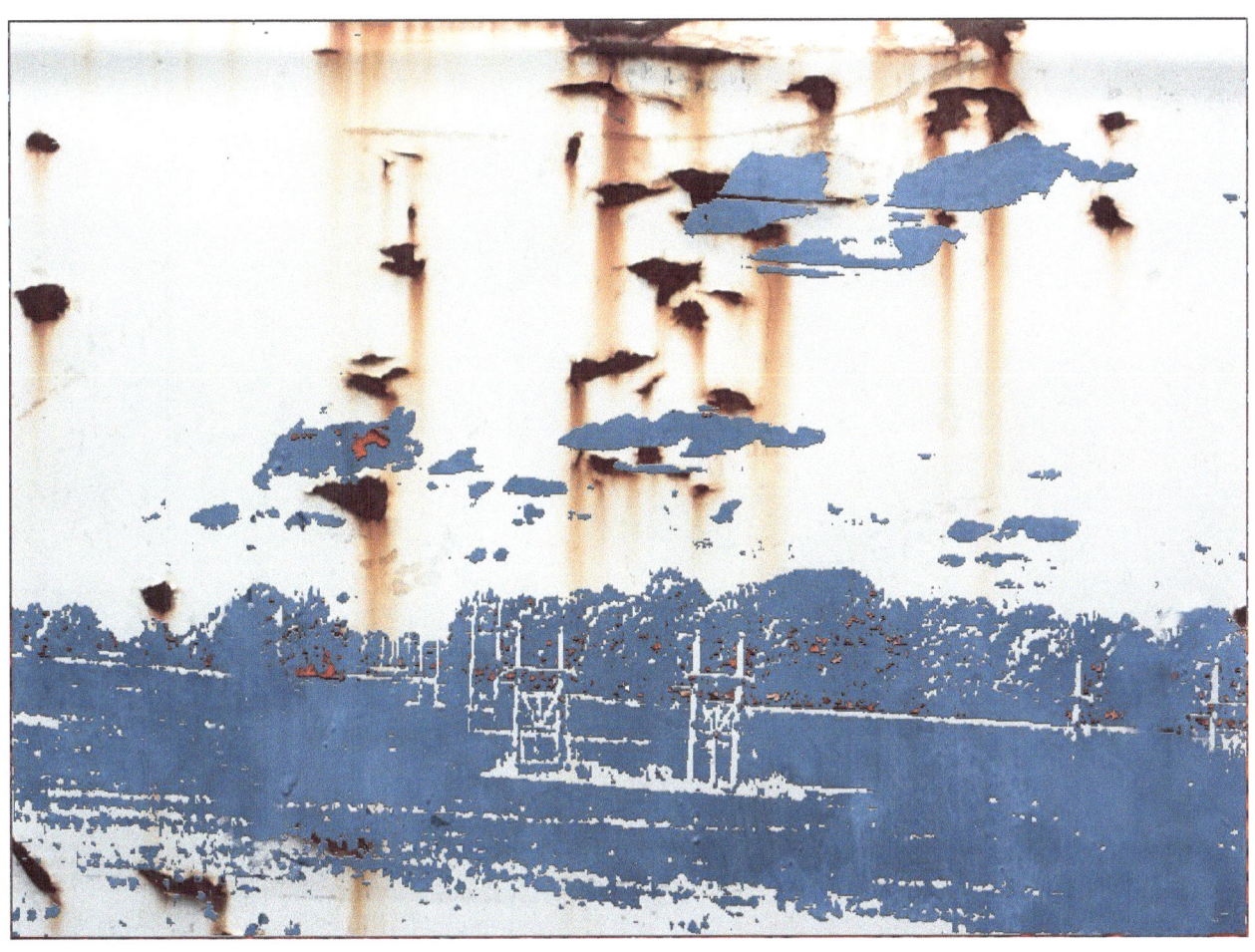

Annihilation of Memory

*"Everything that exists destroying itself, consuming itself and dying, each instant producing itself only in the annihilation of the preceding one, and itself existing only as mortally wounded"**

Screen print on reclaimed enamelled metal sheet

*Bataille, Georges – Visions of Excess

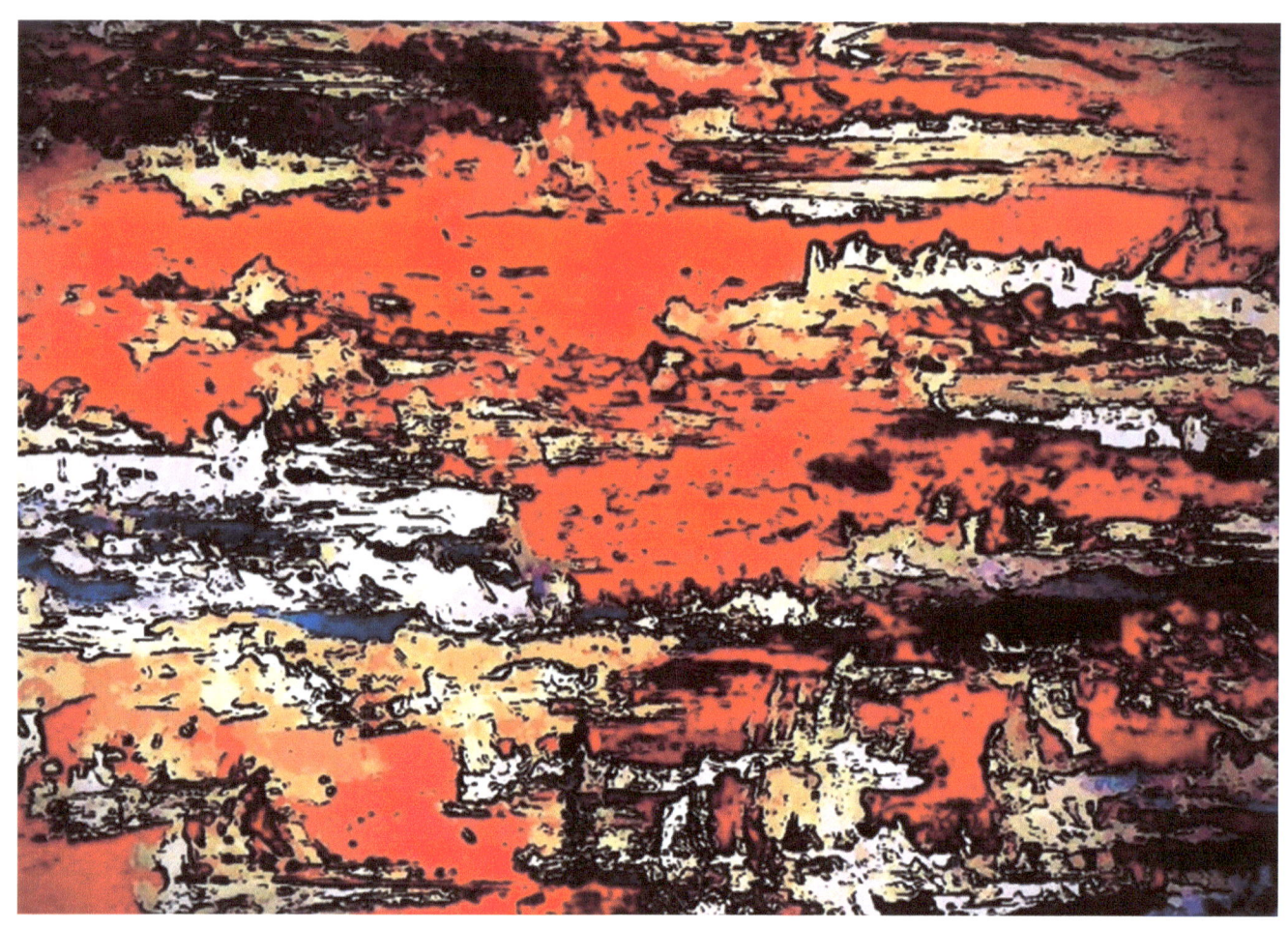

Putrefaction

*"Shamefully, we get life from putrefaction, and death, which reduces us to putrefaction, is no less ignoble than birth"**

Watercolor and gouache screen print on reclaimed stone

*Bataille, Georges – Death (from The Accursed Share)

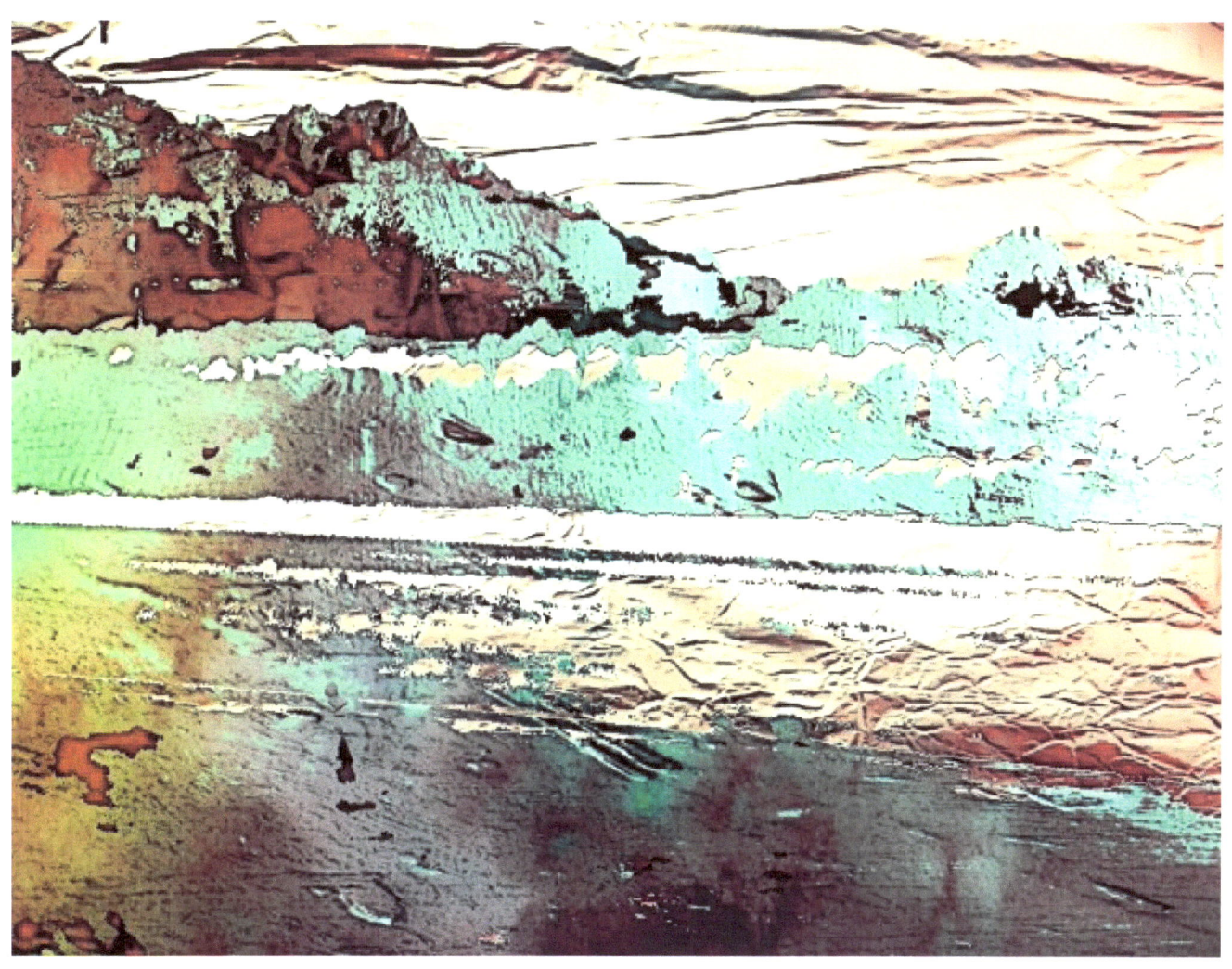

Passionate Mortification

*"I have cultivated my hysteria with pleasure and terror."**

Acrylic, gouache and enamel screen print on aluminium sheeting and reclaimed wood panel

*Baudelaire, Charles : "My Heart Laid Bare," (written c. 1865)

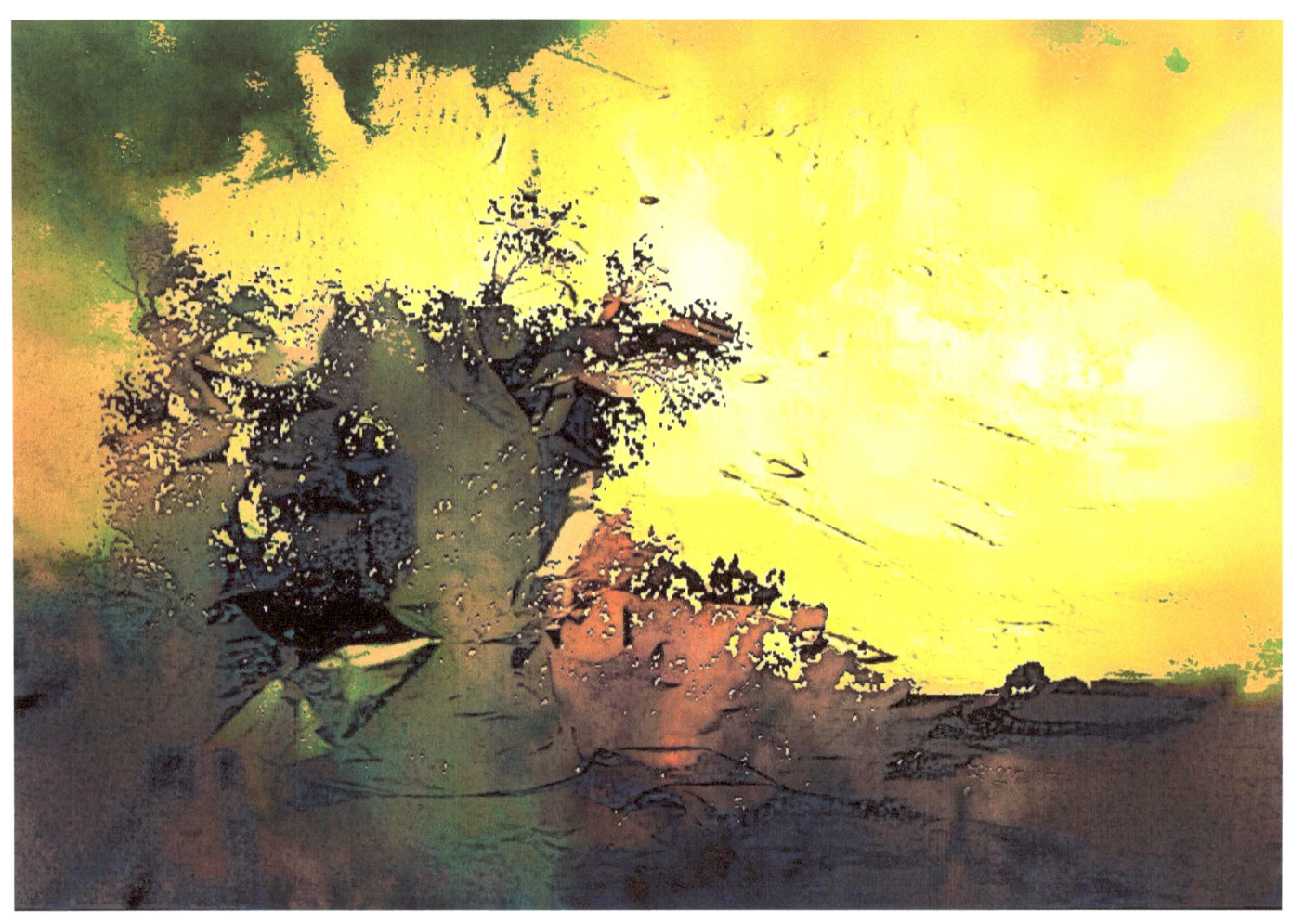

Violent Tide

*"Ah! would that I had spawned a whole knot of vipers, Rather than to have fed this derisive object! Accursed be the night of ephemeral joy When my belly conceived this, my expiation!"**

Watercolor and gouache screen print on reclaimed pine panel

*Baudelaire, Charles : Benediction (From The Flowers of Evil)

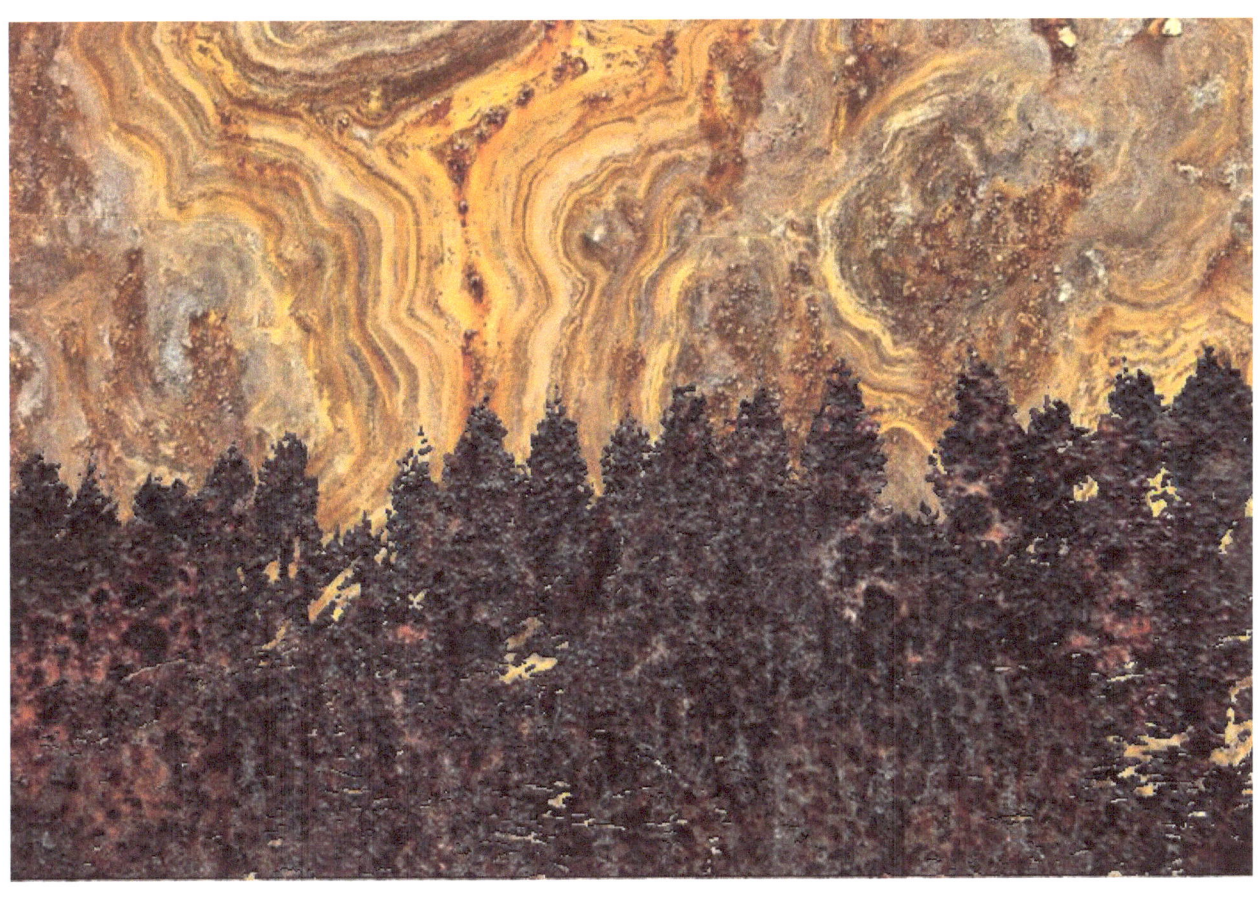

The Fire

*"Pleasure only starts once the worm has got into the fruit, to become delightful happiness must be tainted with poison"**

Blowtorch on reclaimed Pine Panel with Aluminium Oxide sheeting

*Bataille, Georges (Quote)

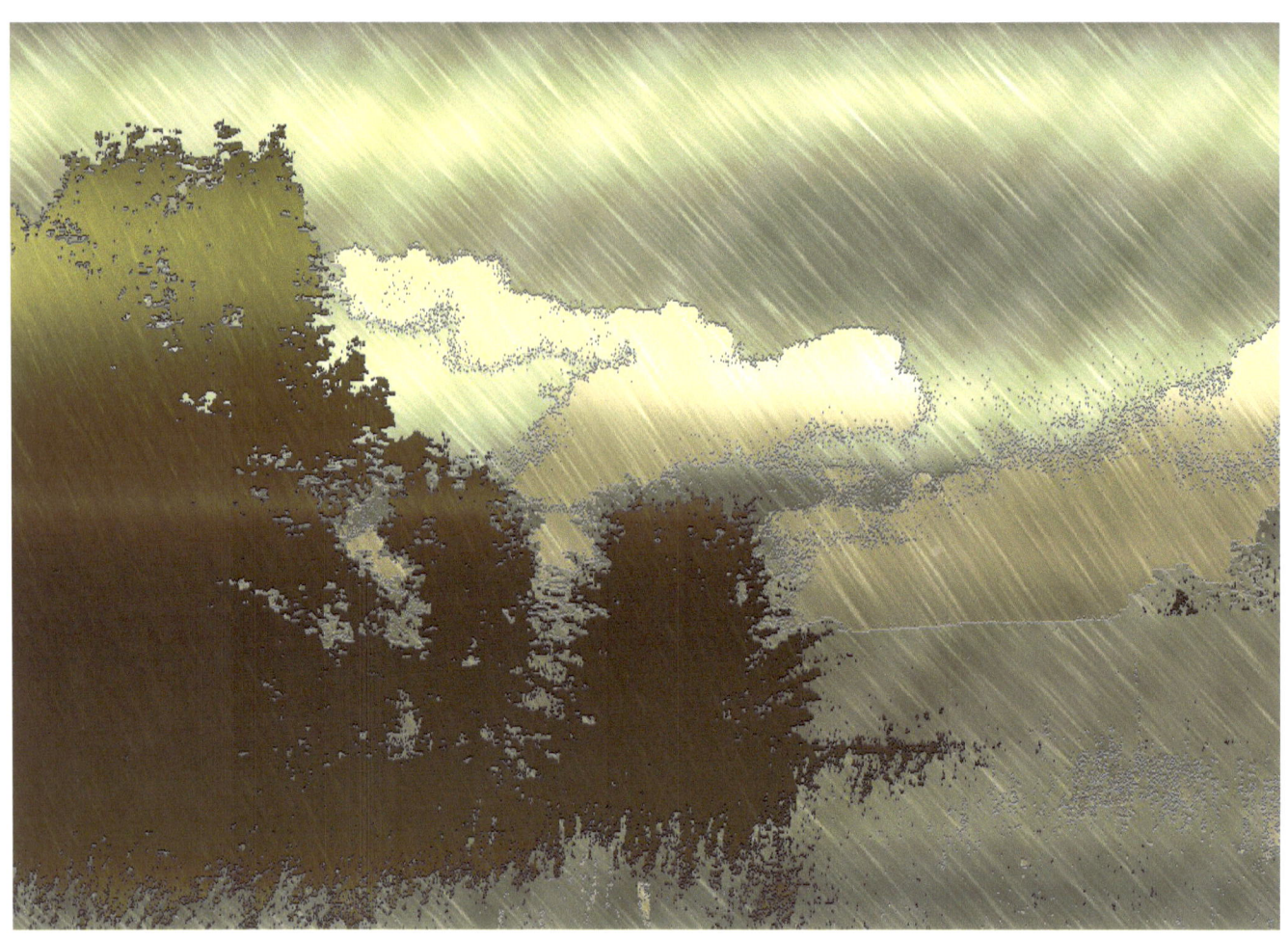

Copper Sky

*"An artist is an artist only because of his exquisite sense of beauty, a sense which shows him intoxicating pleasures, but which at the same time implies and contains an equally exquisite sense of all deformities and all disproportion,"**

Etching on Copper plate sheeting over reclaimed metal board

*Baudelaire, Charles : Quote

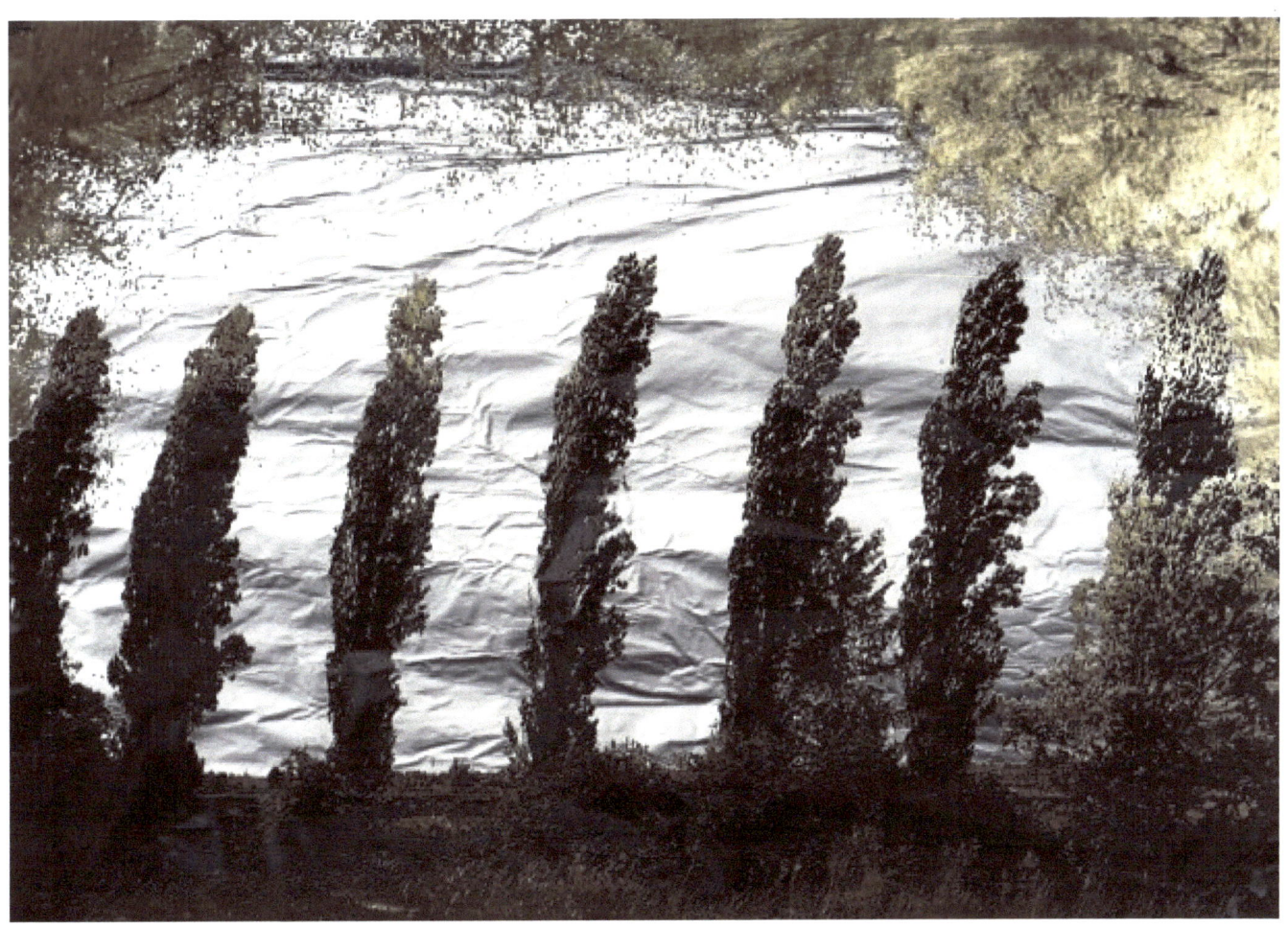

Cohesion

*"Life has always taken place in a tumult without apparent cohesion, but it only finds its grandeur and its reality in ecstasy and in ecstatic love."**

Copper plated etching with aluminium sheet and acrylic polymer and acrylic black acetate

*Bataille, Georges (Quote)

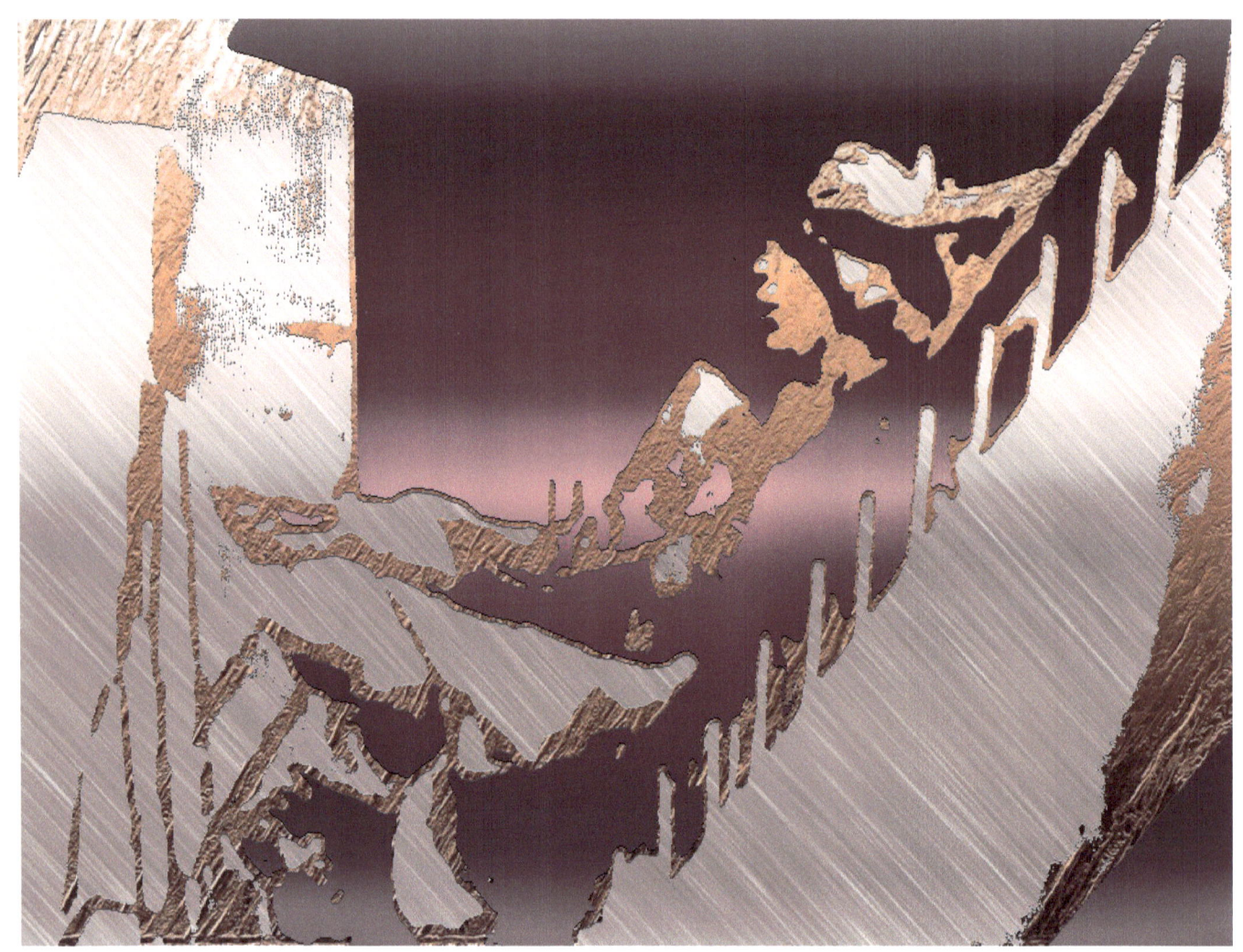

Reaching Out

*"The big bell tolls: damp hearth-logs seem to mock, whistling, the sniffle-snuffle of the clock, while in the play of odours stale with must, reminders of a dropsical old crone, the knave of hearts and queen of spades alone darkly discuss a passion turned to dust."**

Aluminium Sheeting, Copper and Zinc plated sheeting and gold and copper leaf etching

*Baudelaire, Charles : Spleen (Pluviose irrite)
Trans : William Aggeler, The Flowers of Evil (Fresno, CA: Academy Library Guild, 1954)

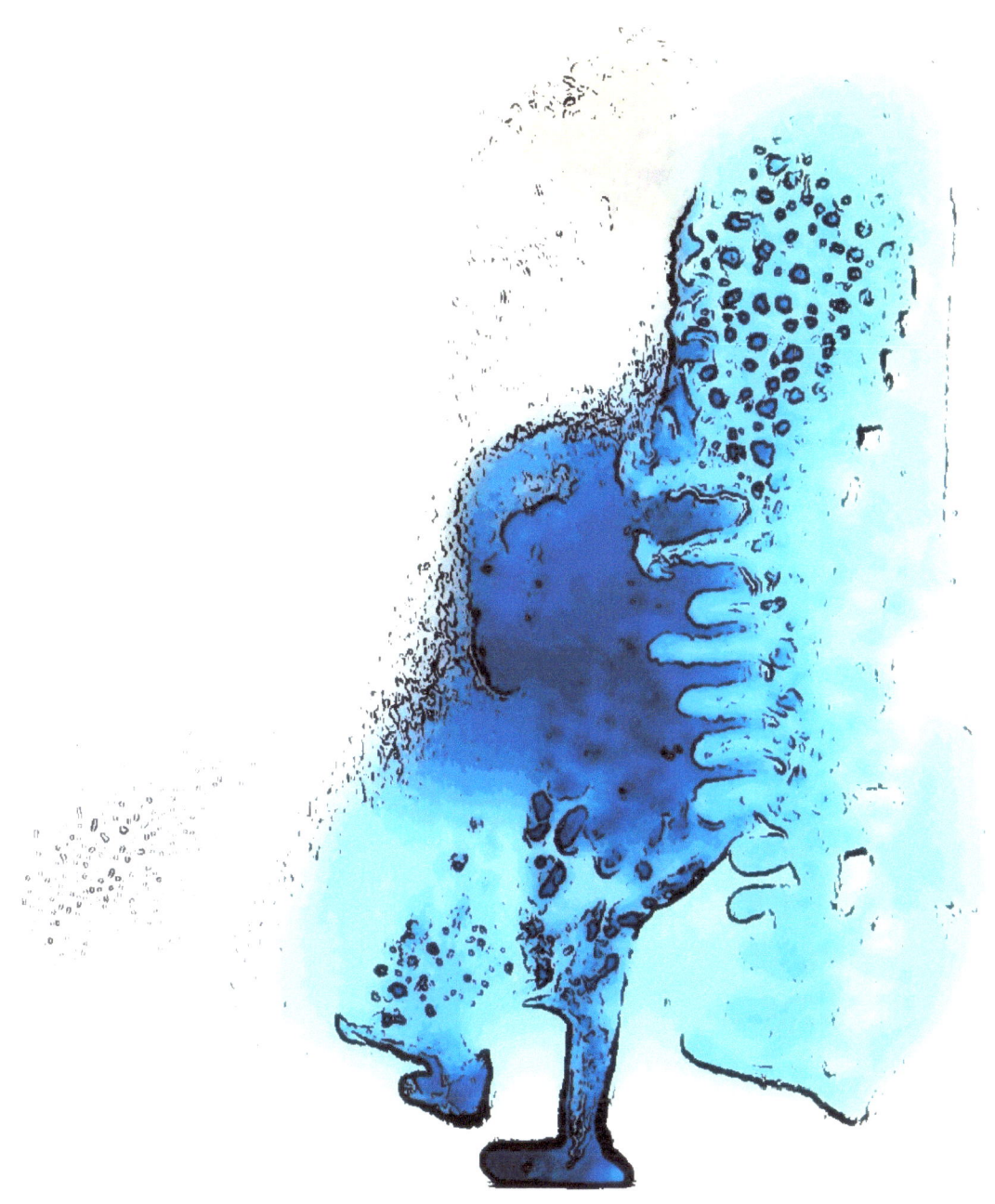

Metamorphosis

*"What strange phenomena we find in a great city, all we need do is stroll about with our eyes open. Life swarms with innocent monsters."**

Watercolor and Gouache

+Baudelaire, Charles : Miss Scalpel (La Fanfarlo)

ACKNOWLEDGEMENTS

All of the base materials used (stone, pine wood panels, metal sheeting etc) were relcaimed and recycled from various sources – some from municipal rubbish dumps, others from the kindness of people's hearts who chose to save bits and pieces for me when decorating their houses!

Grateful thanks go out to all of those people who KNOW who they are, who constantly and consistently, make my life possible and manageable.

If I mention anyone by name I will only leave people out so just assume you are included in the above dedication!

Thank you.

THE END

www.ingramcontent.com/pod-product-compliance
Lightning Source LLC
Chambersburg PA
CBHW050434180526
45159CB00006B/2533